D1631496

The Highway Rat

By Julia Donaldson and illustrated by Axel Scheffler

ALISON GREEN BOOKS

The Highway Rat was a baddie.
 The Highway Rat was a beast.
He took what he wanted and ate what he took.
 His life was one long feast.
His teeth were sharp and yellow,
 his manners were rough and rude,
And the Highway Rat went riding –
 Riding – riding –
Riding along the highway
 and stealing the travellers' food.

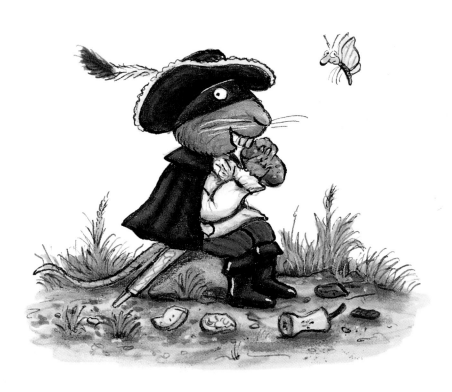

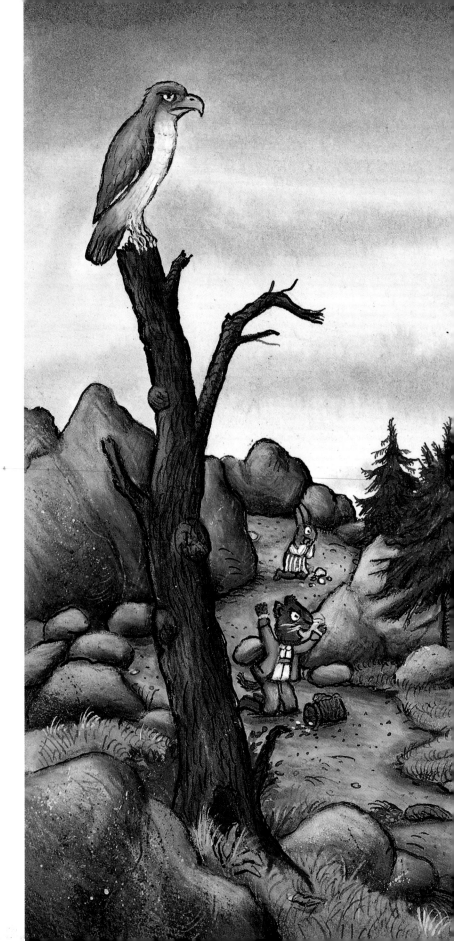

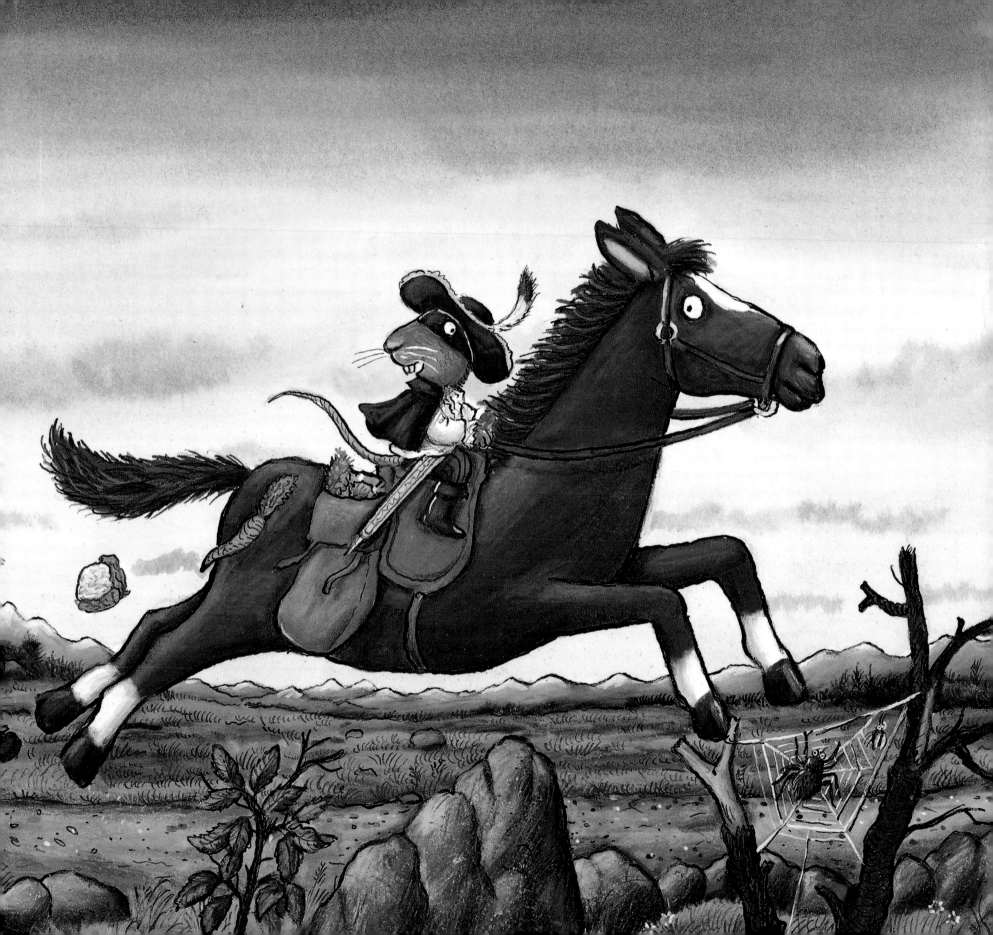

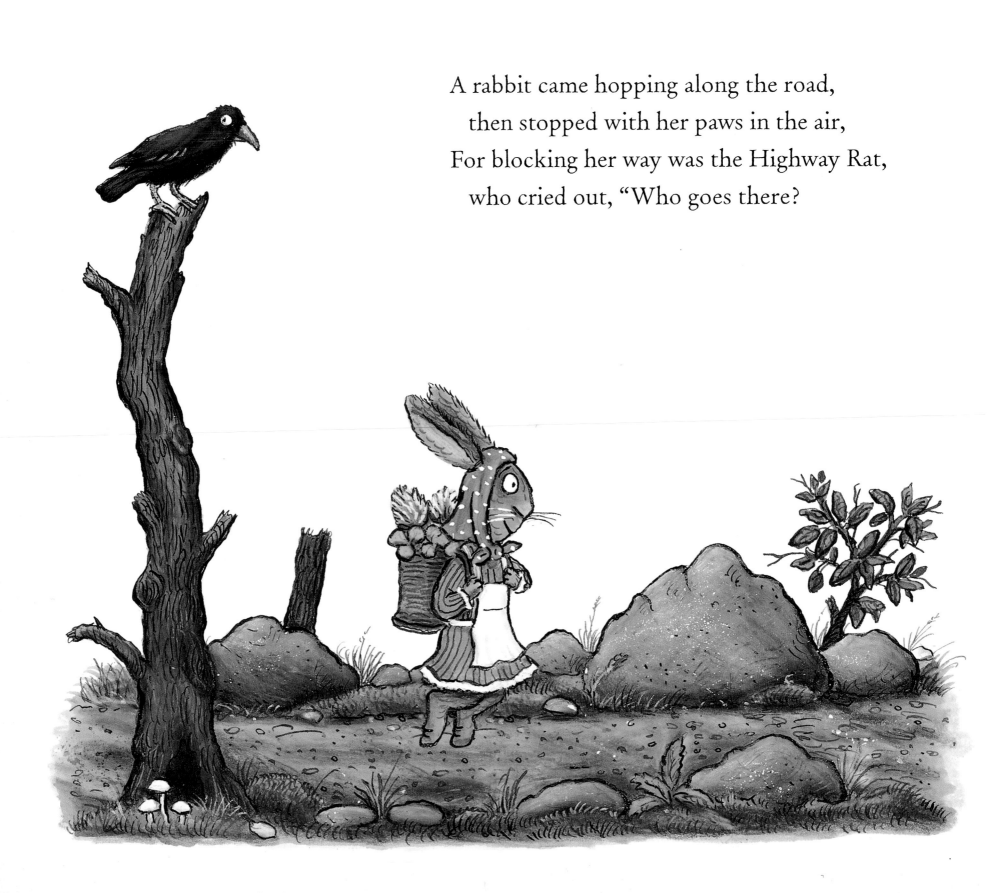

A rabbit came hopping along the road,
 then stopped with her paws in the air,
For blocking her way was the Highway Rat,
 who cried out, "Who goes there?

"Give me your pastries and puddings!
Give me your chocolate and cake!
For I am the Rat of the Highway,
The Highway – the Highway –
Yes I am the Rat of the Highway,
and whatever I want I take."

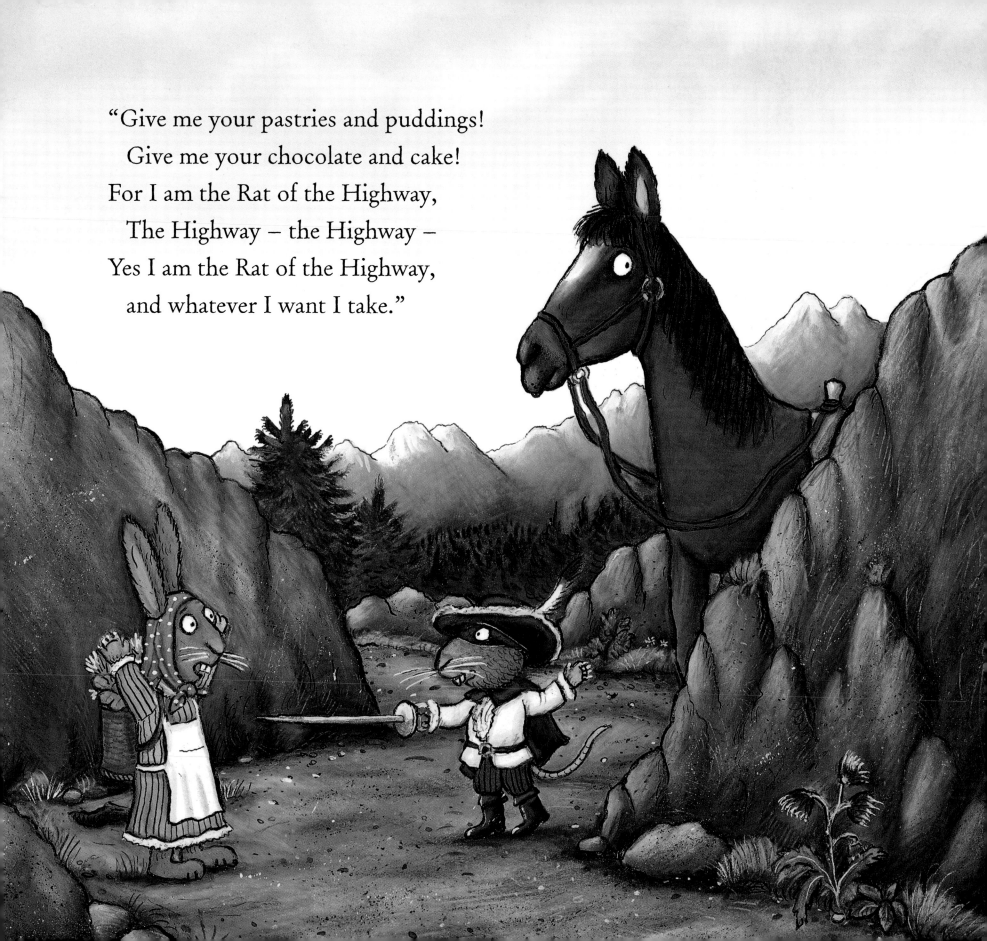

"I have no cakes," the rabbit replied.
 "I just have a bunch of clover."
The Highway Rat gave a scornful look
 but he ordered, "Hand it over.

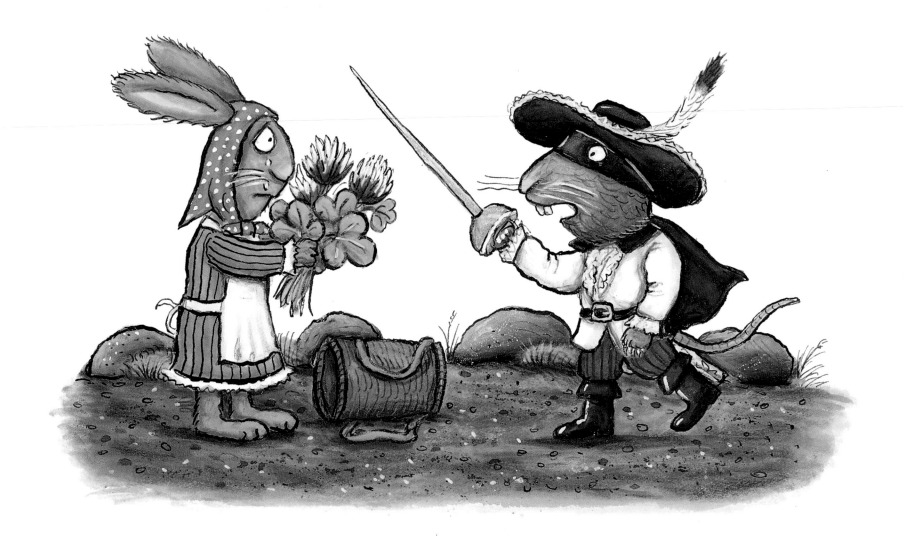

"This clover is bound to be tasteless.
 This clover is dull as can be,
But I am the Rat of the Highway,
 and this clover belongs to *me!*"

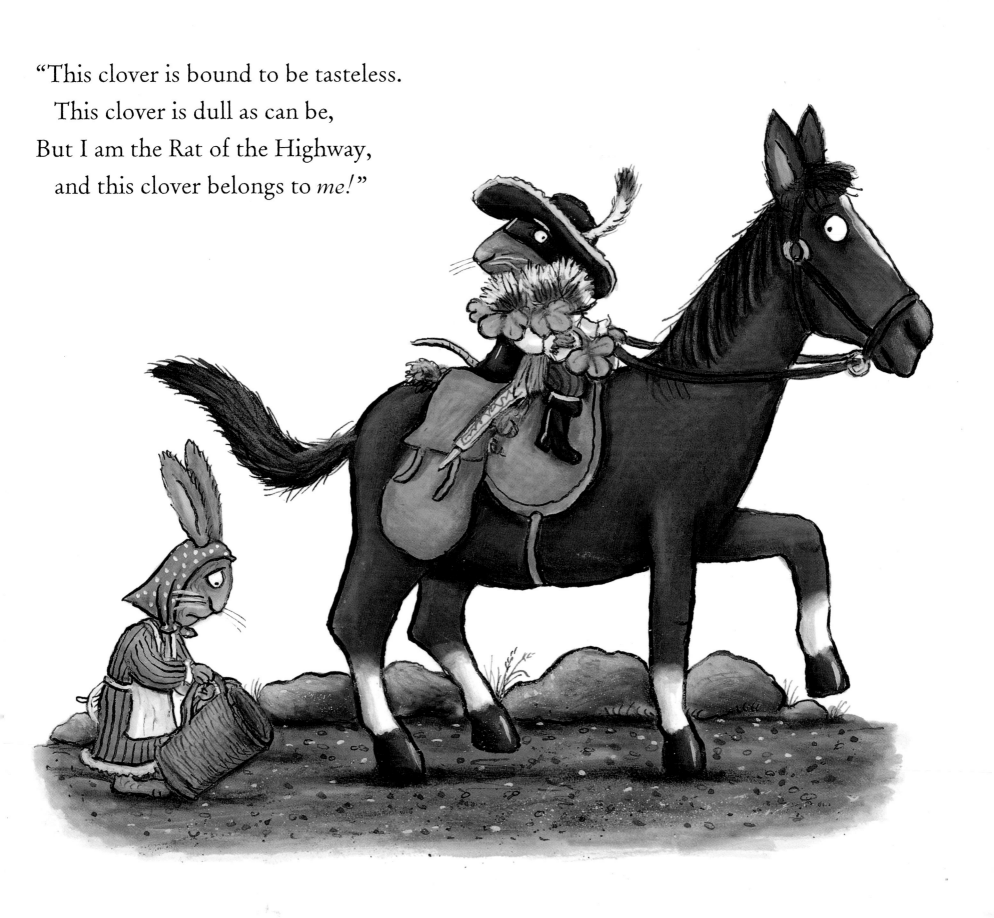

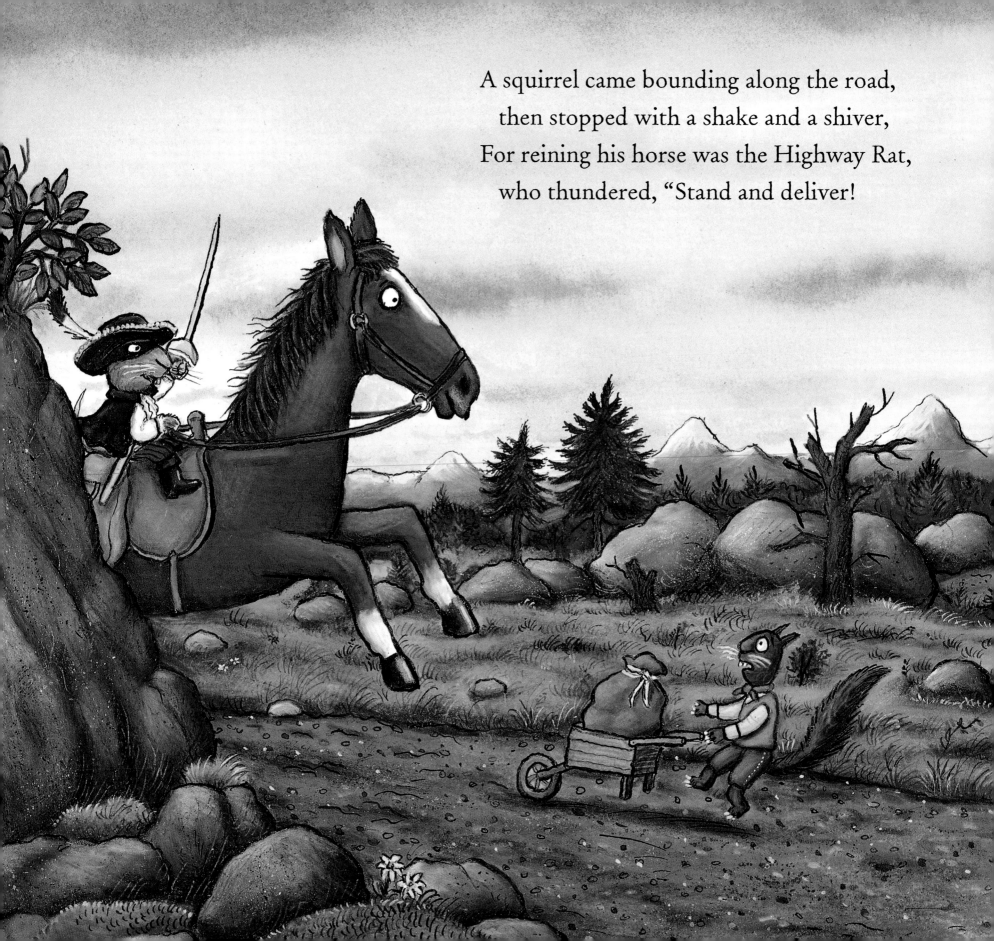

A squirrel came bounding along the road,
then stopped with a shake and a shiver,
For reining his horse was the Highway Rat,
who thundered, "Stand and deliver!

"Give me your buns and your biscuits!
Give me your chocolate éclairs!
For I am the Rat of the Highway,
The Highway – the Highway –
Yes, I am the Rat of the Highway,
and the Rat Thief never shares."

"I have no buns," the squirrel replied.
"I just have a sack of nuts."

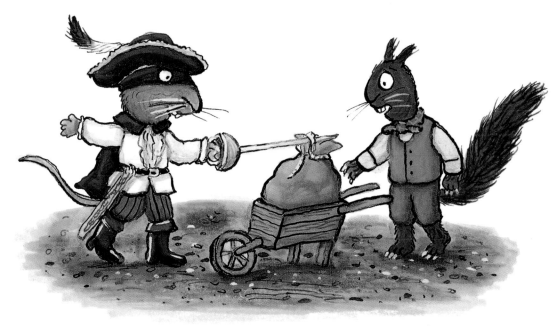

The robber snatched the sack and snarled,
"I'll have no ifs or buts!

These nuts are probably rotten.
These nuts are as hard as can be,
But I am the Rat of the Highway,
and these nuts belong to *me!*"

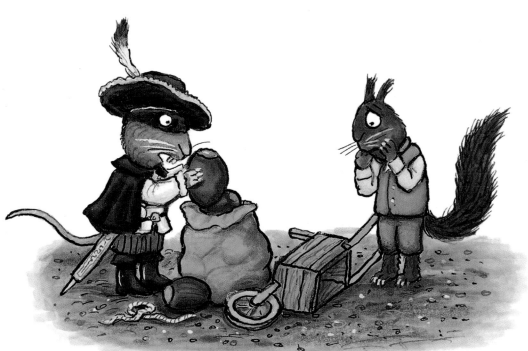

Some ants came crawling along the road,
then stopped with a somersault,
For baring his teeth was the Highway Rat,
who bellowed a deafening, "Halt!
Give me your sweets and your lollies!
Give me your toffees and chews!

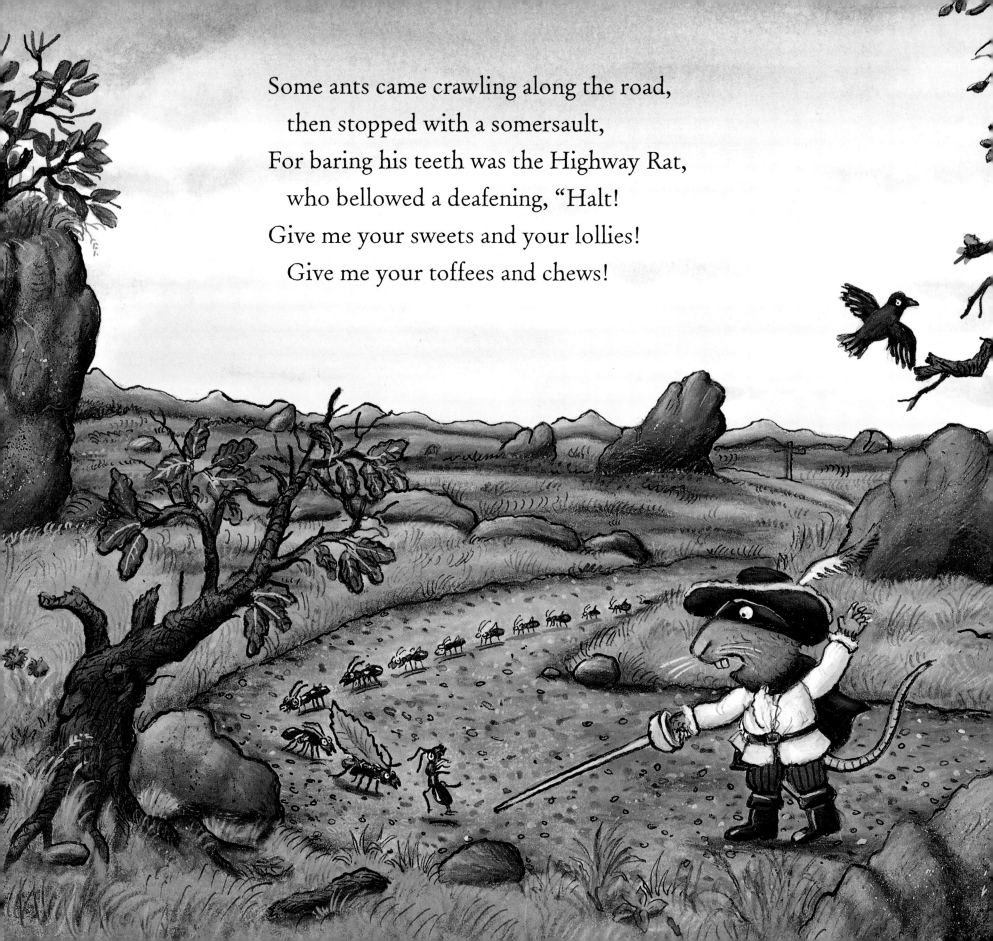

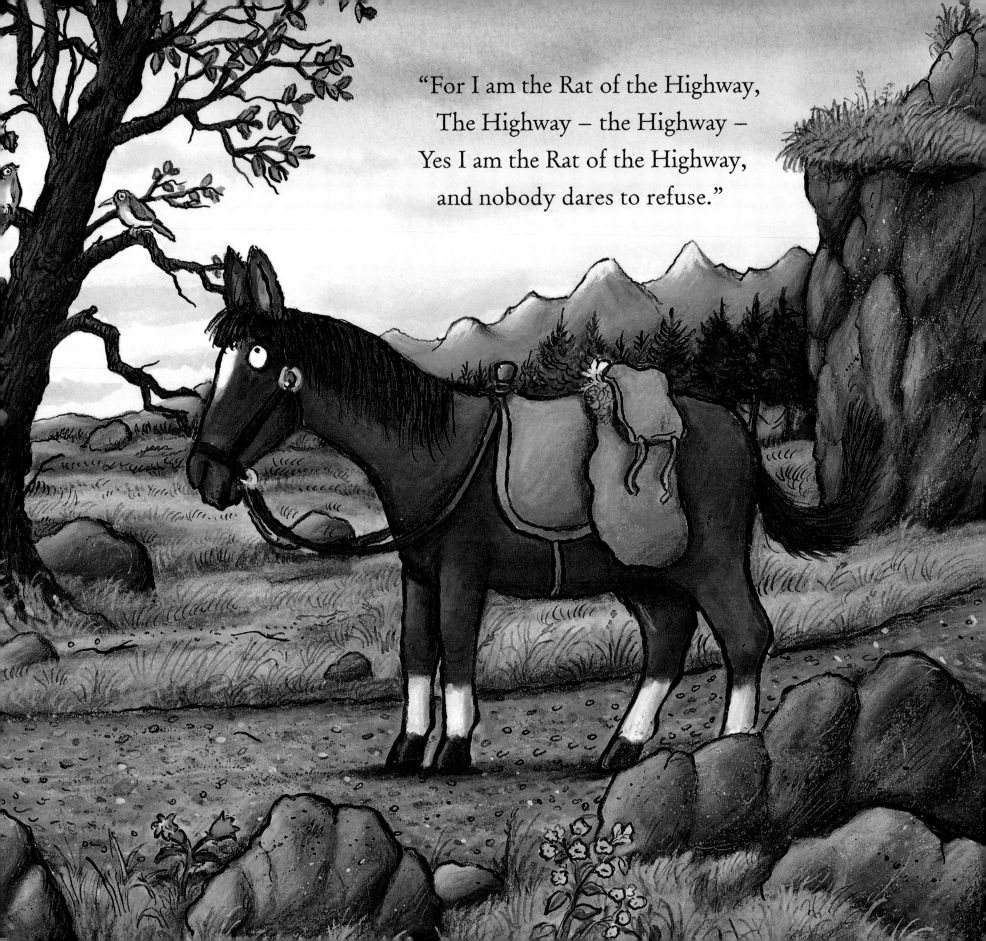

"For I am the Rat of the Highway,
The Highway – the Highway –
Yes I am the Rat of the Highway,
and nobody dares to refuse."

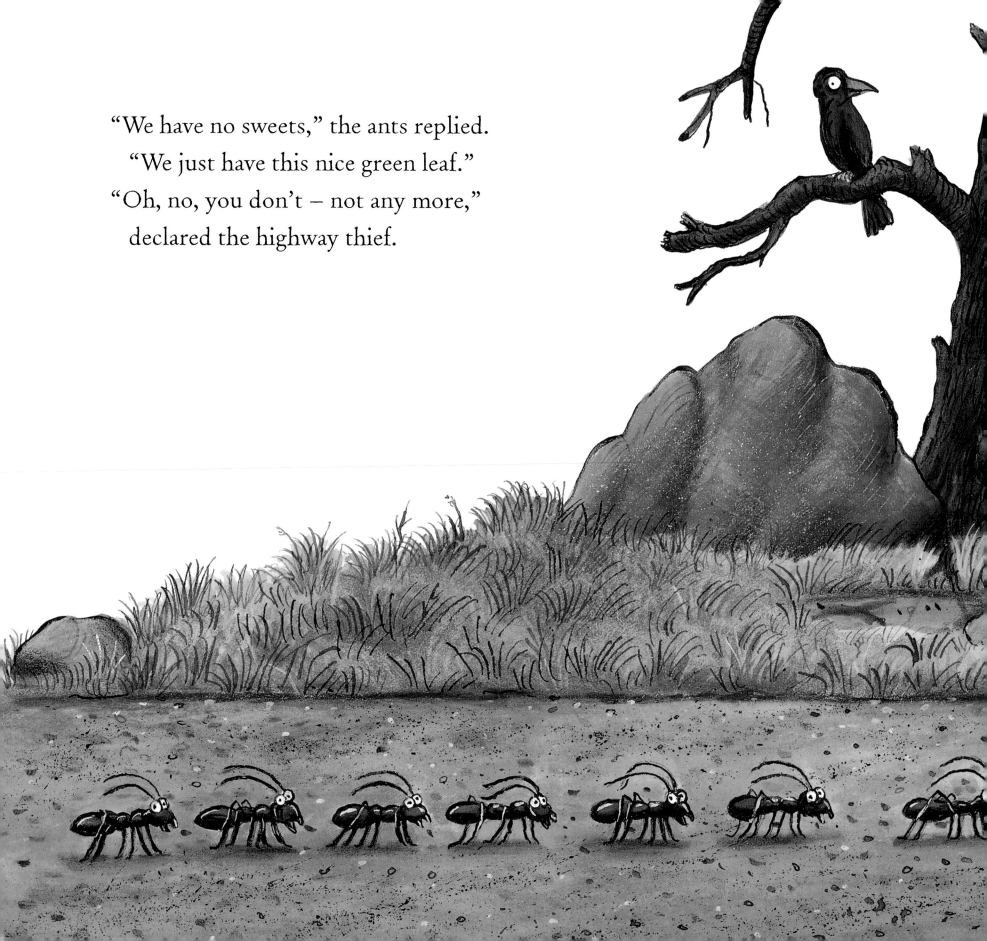

"We have no sweets," the ants replied.
 "We just have this nice green leaf."
"Oh, no, you don't – not any more,"
 declared the highway thief.

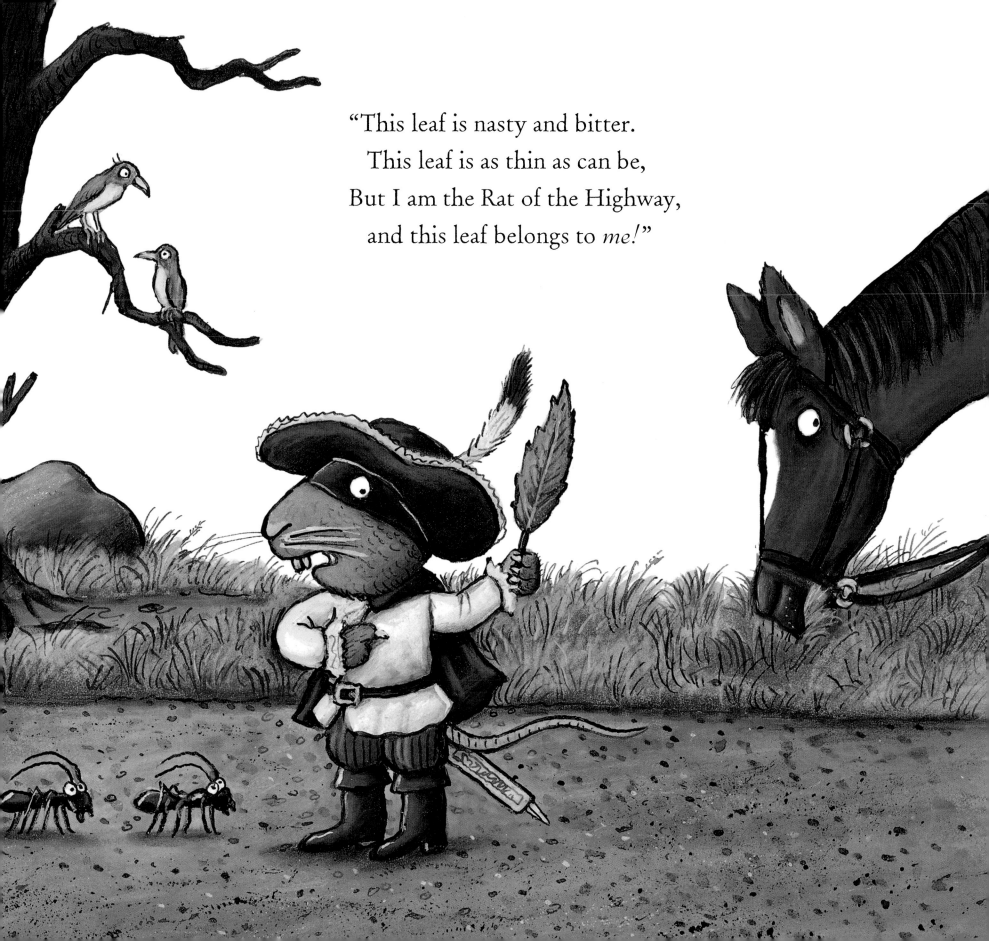

"This leaf is nasty and bitter.
This leaf is as thin as can be,
But I am the Rat of the Highway,
and this leaf belongs to *me!*"

With never a please or a thank you,
the Rat carried on in this way.

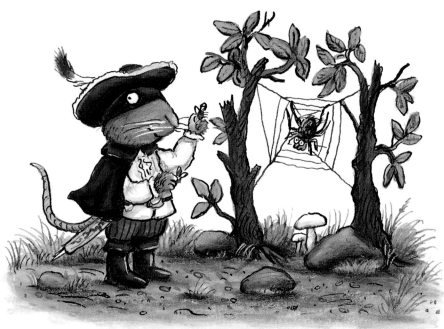

Flies from a spider!

Milk from a cat!

He once stole his own horse's hay!

The creatures who travelled the highway
grew thinner and thinner and thinner,

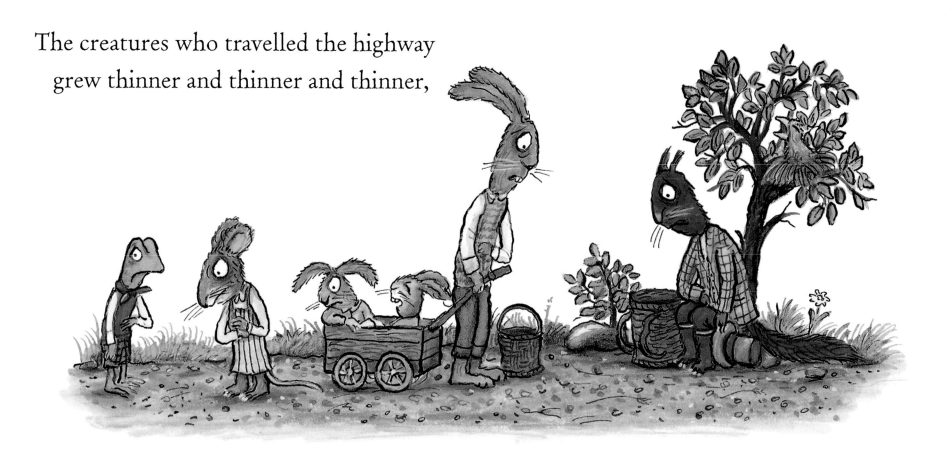

While the Highway Rat grew horribly fat
from eating up everyone's dinner.

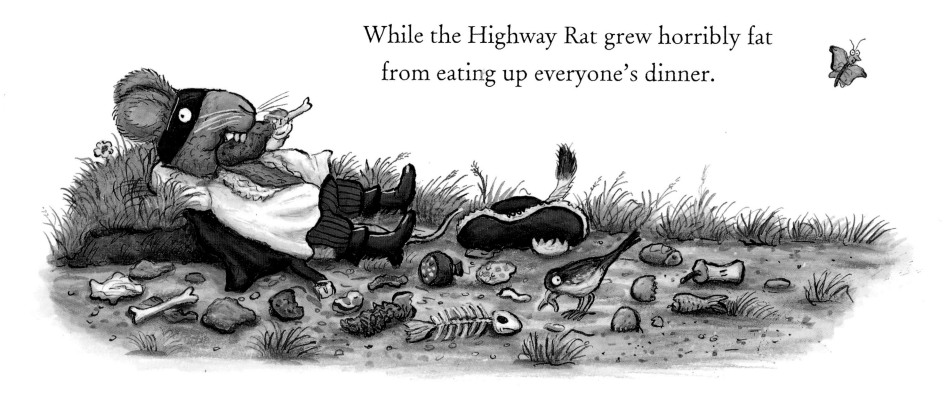

A duck came waddling down the road,
then stopped with a "How do you do?"

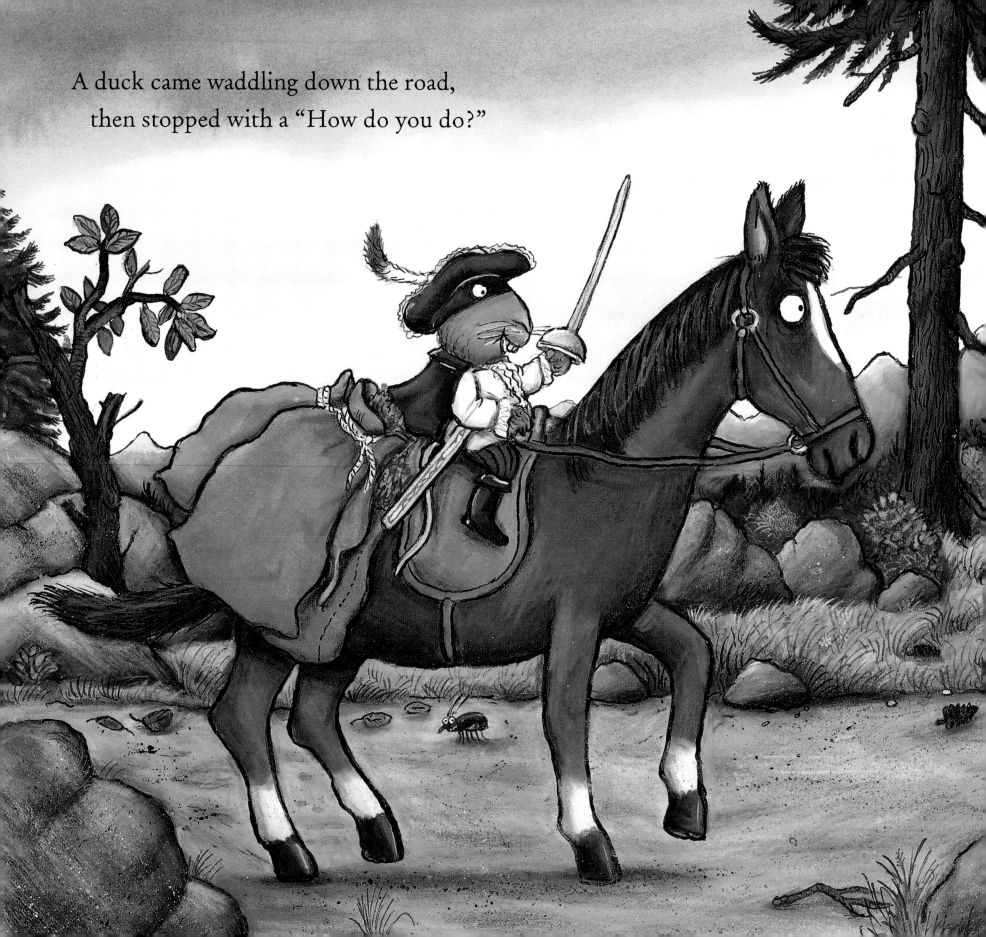

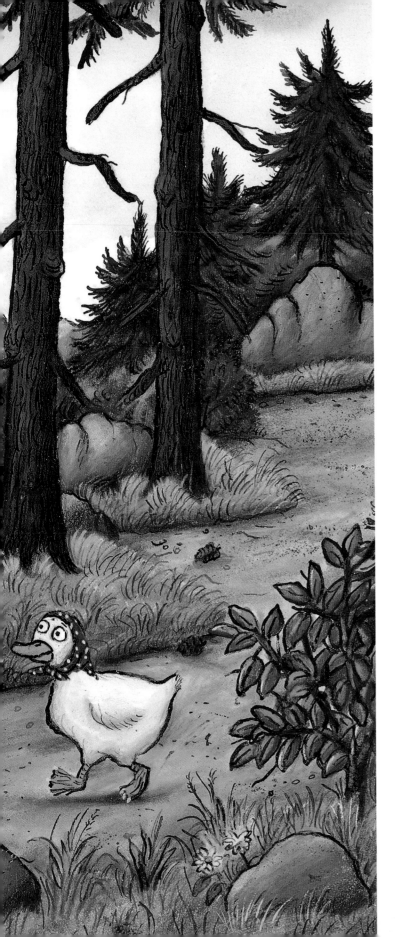

"I see you have nothing," the Rat complained.
"In that case, I'll have to eat *you!*
I doubt if you're terribly juicy.
Most likely you're tough as can be,

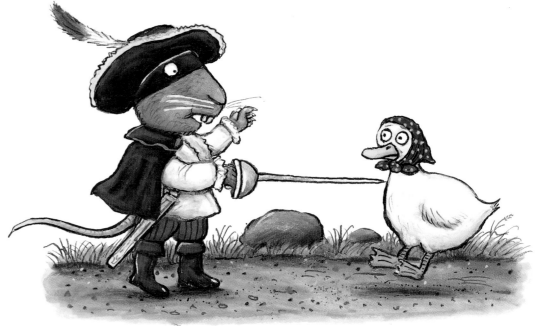

"But I am the Rat of the Highway –
The Highway – the Highway –
Yes I am the Rat of the Highway,
and I fancy a duck for tea!"

"Hang on," quacked the duck, "for I have a sister
 with goodies you might prefer.
I know that she'd love to meet you
 and I'm certain that you'd like *her*,
For in her cave, her deep dark cave,
 right at the top of the hill,
Are biscuits and buns a-plenty
 and there you may eat your fill."

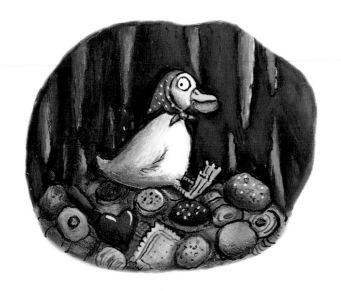

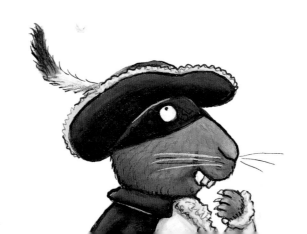

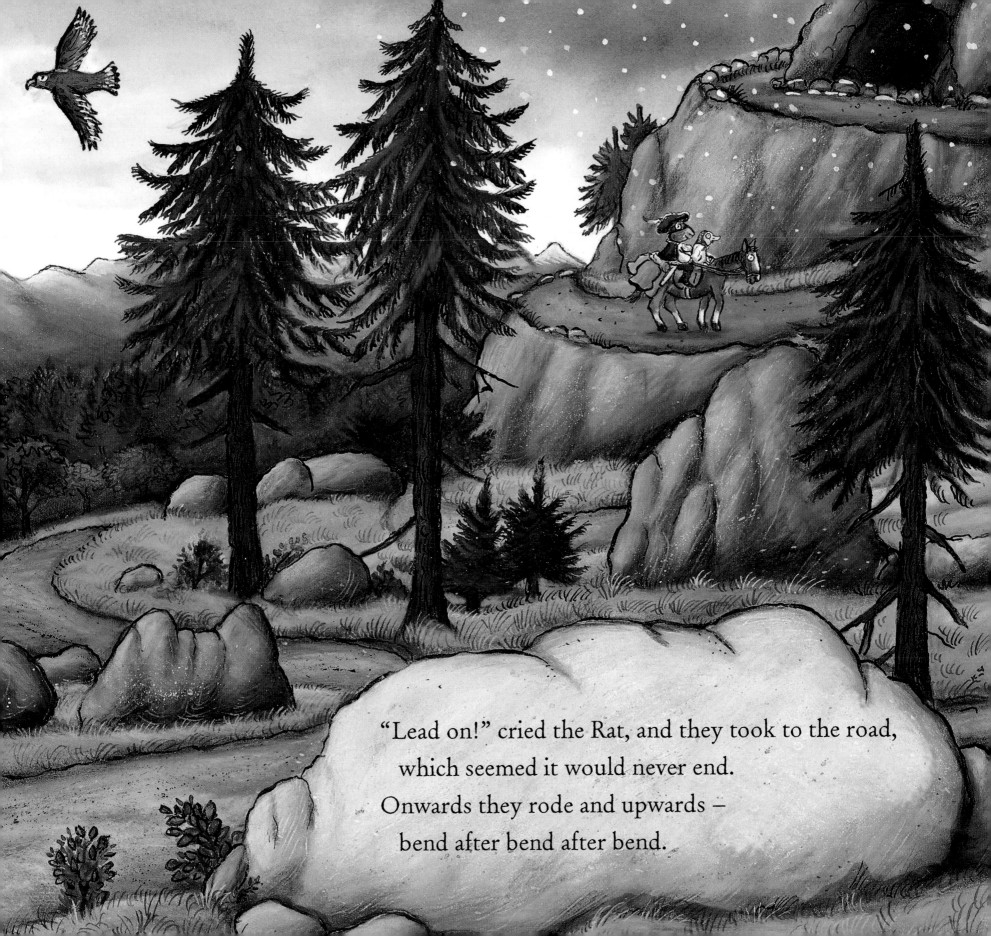

"Lead on!" cried the Rat, and they took to the road,
which seemed it would never end.
Onwards they rode and upwards –
bend after bend after bend.

At last they came to a lonely cave,
 and the duck began to quack.
She quacked, "Good evening sister –
 Sister – sister –"

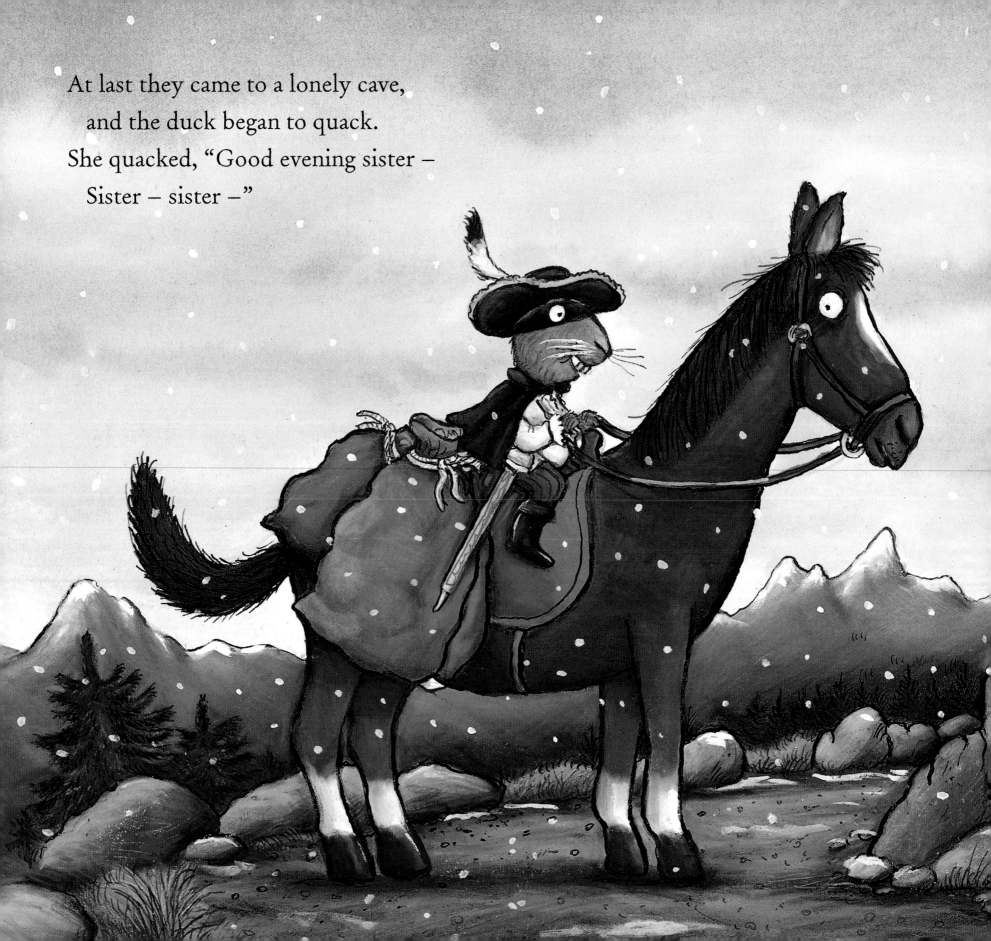

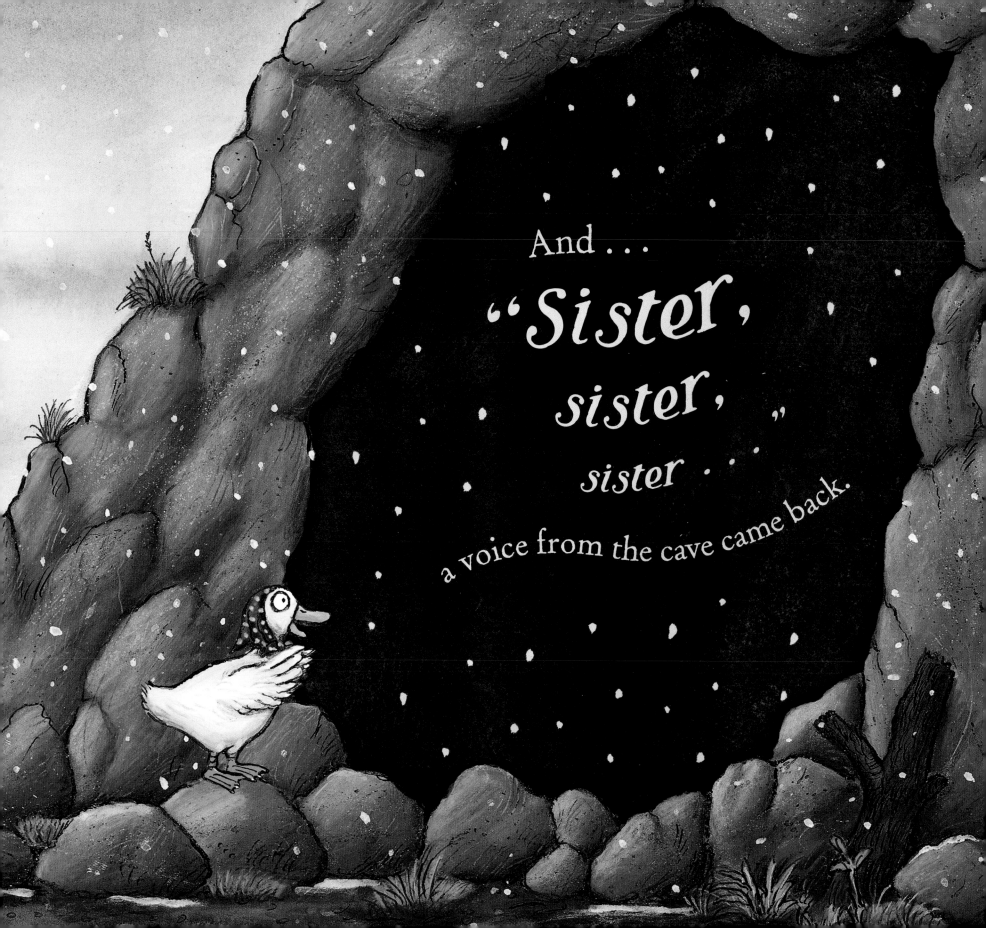

And . . .
"*Sister*,
sister,"
sister . . .
a voice from the cave came back.

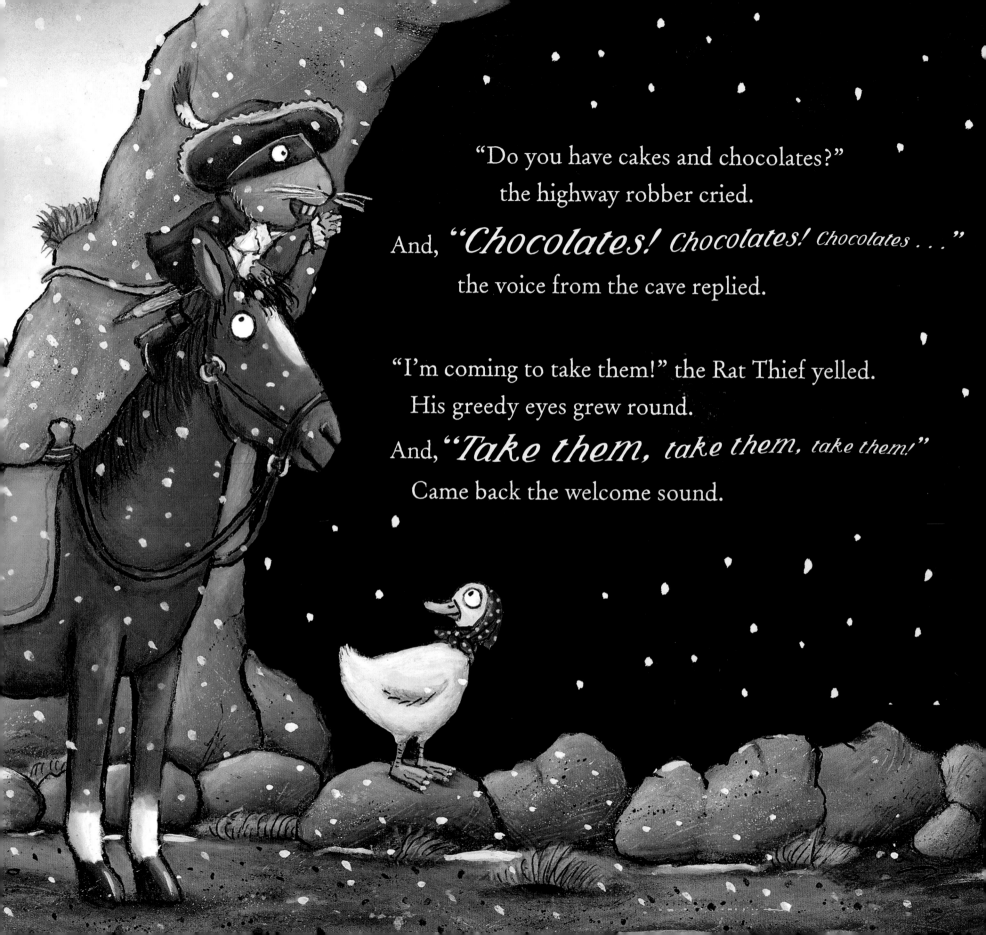

"Do you have cakes and chocolates?"
the highway robber cried.
And, *"Chocolates! Chocolates! Chocolates . . ."*
the voice from the cave replied.

"I'm coming to take them!" the Rat Thief yelled.
His greedy eyes grew round.
And, *"Take them, take them, take them!"*
Came back the welcome sound.

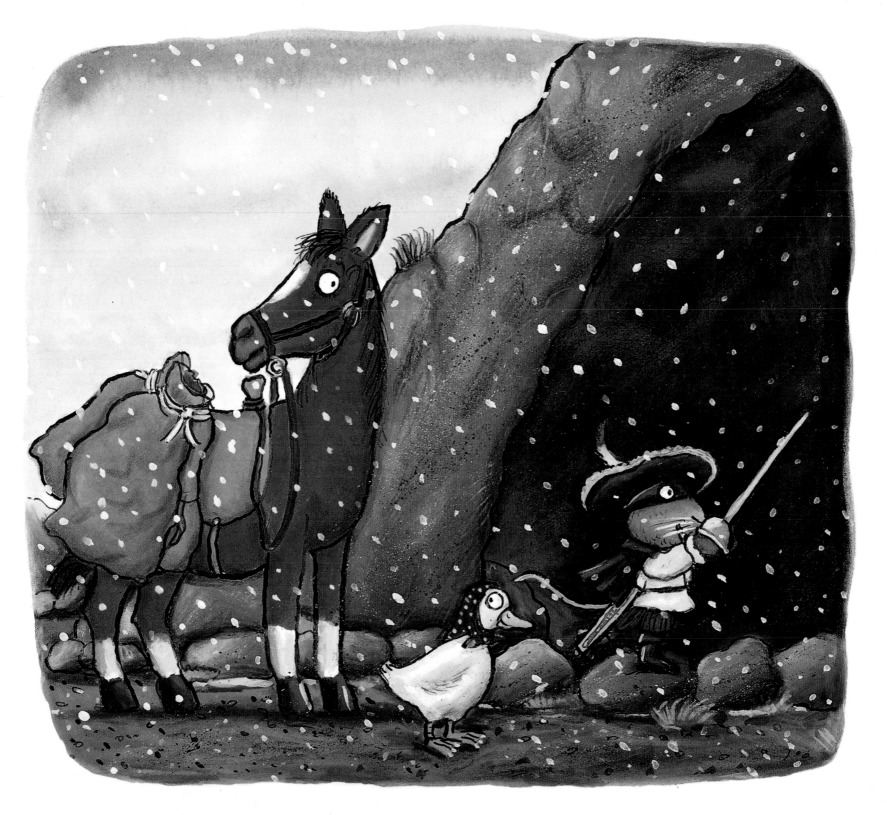

The Highway Rat leapt off his horse. Into the cave he strode.

The duck took hold of the horse's reins
and galloped down the road.

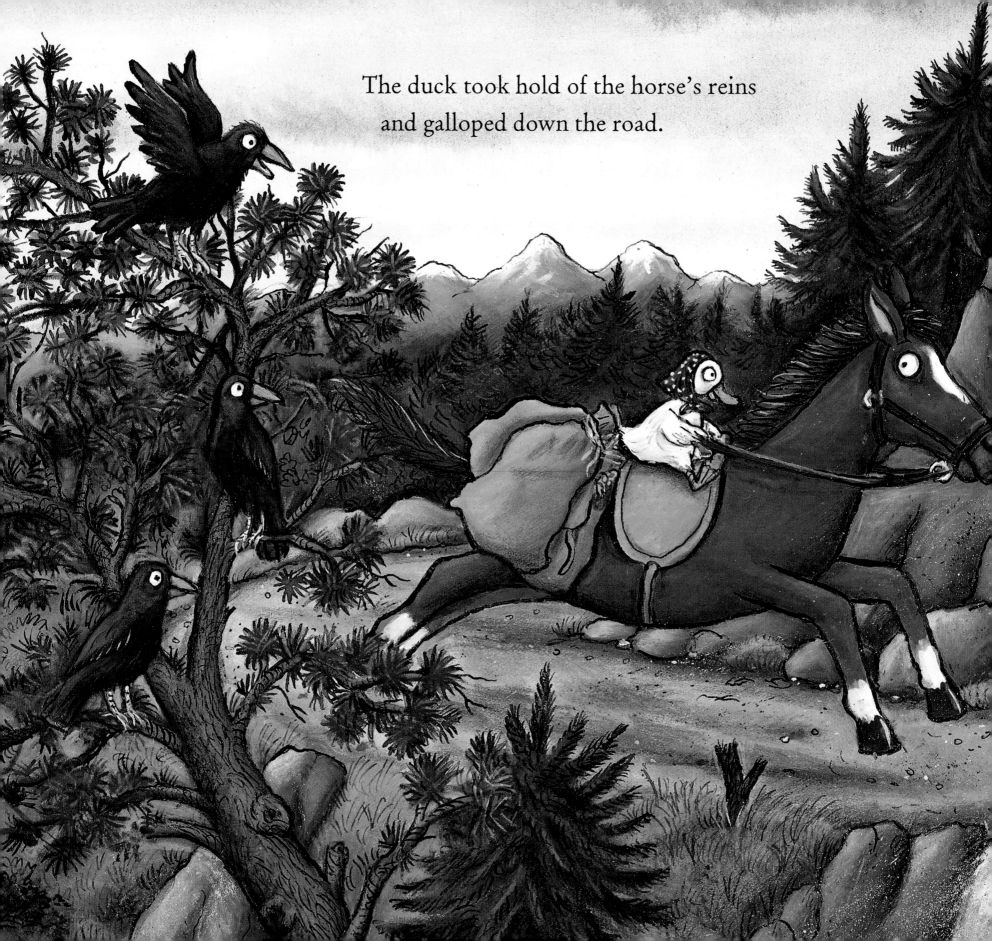

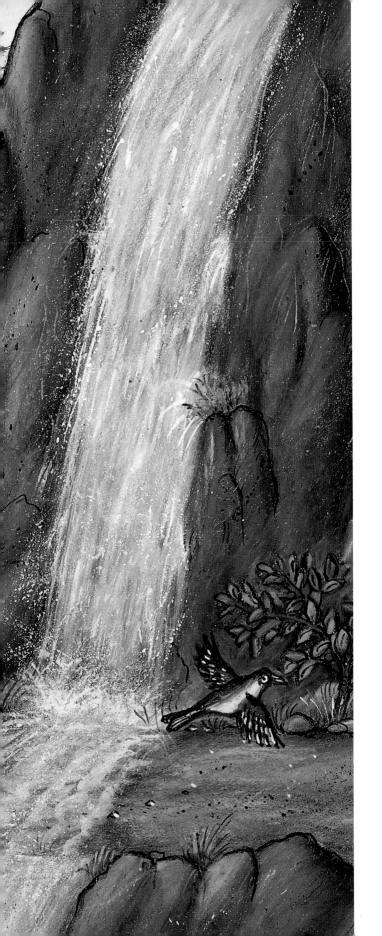

Faster and ever faster, following all the bends,
The plucky young duck went riding –
Riding – riding –
Galloping down the highway,
back to her hungry friends.

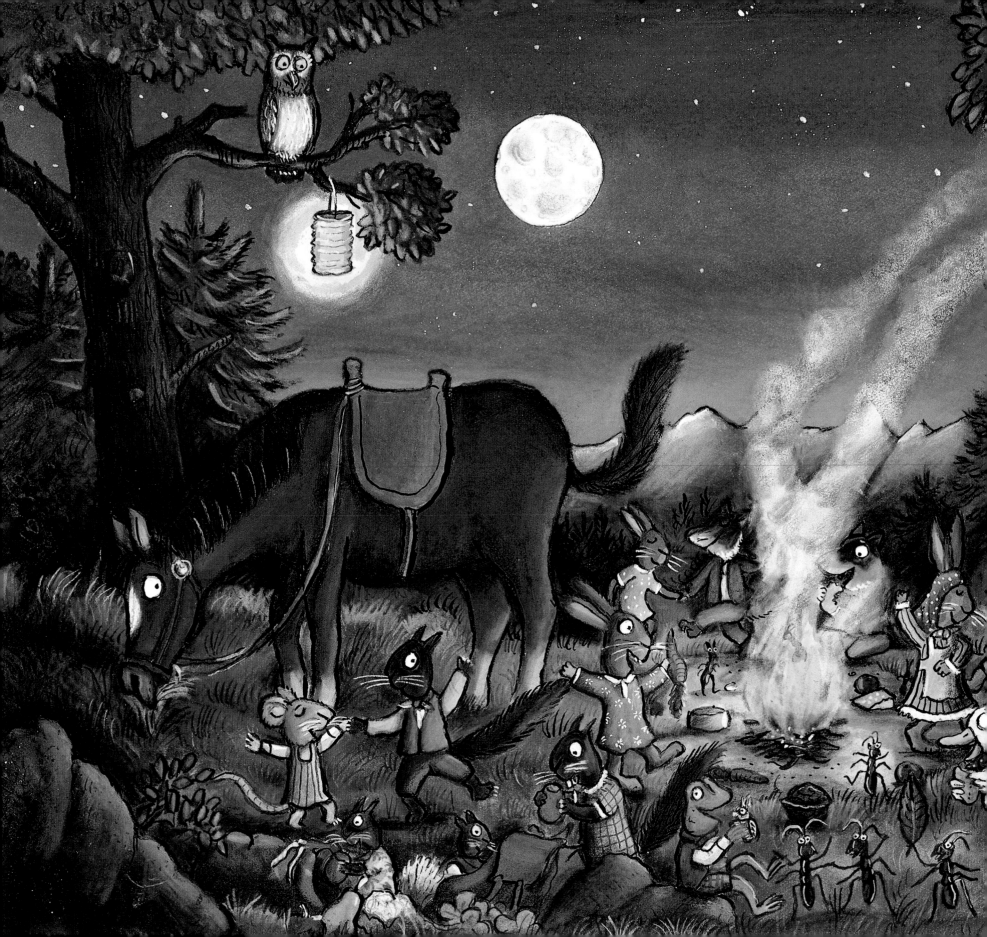

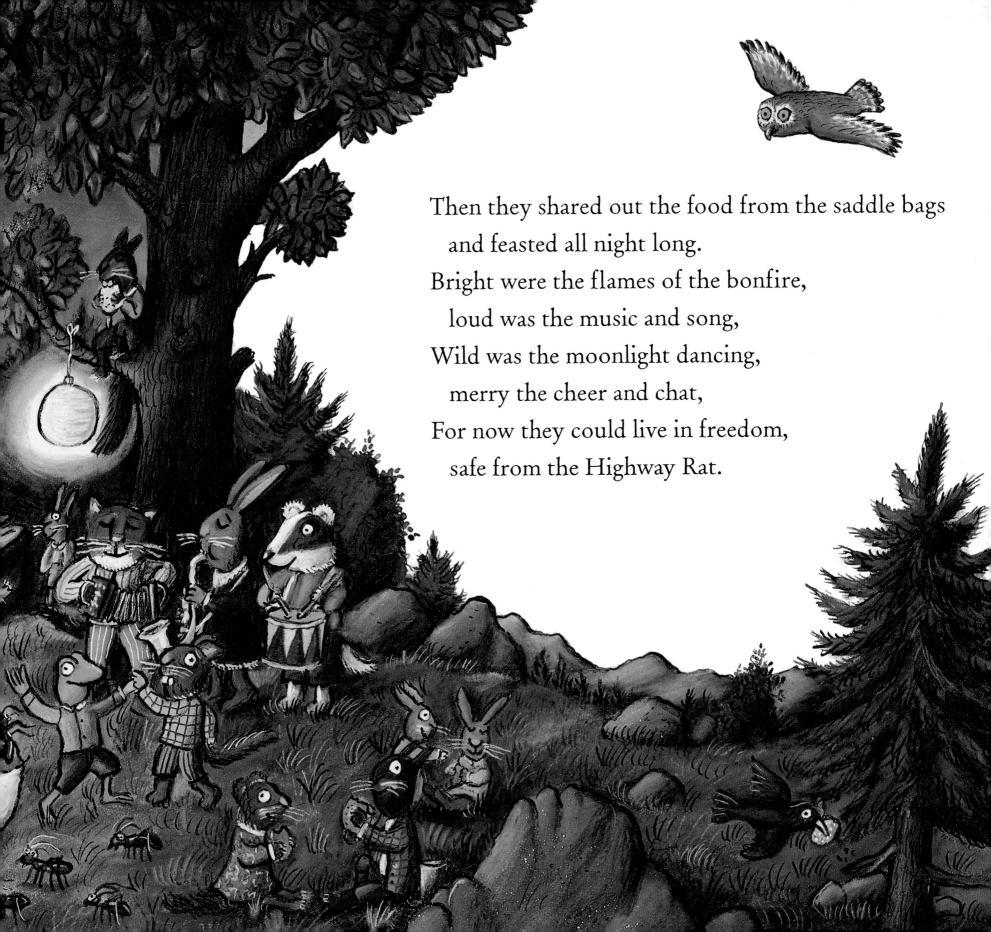

Then they shared out the food from the saddle bags
and feasted all night long.
Bright were the flames of the bonfire,
loud was the music and song,
Wild was the moonlight dancing,
merry the cheer and chat,
For now they could live in freedom,
safe from the Highway Rat.

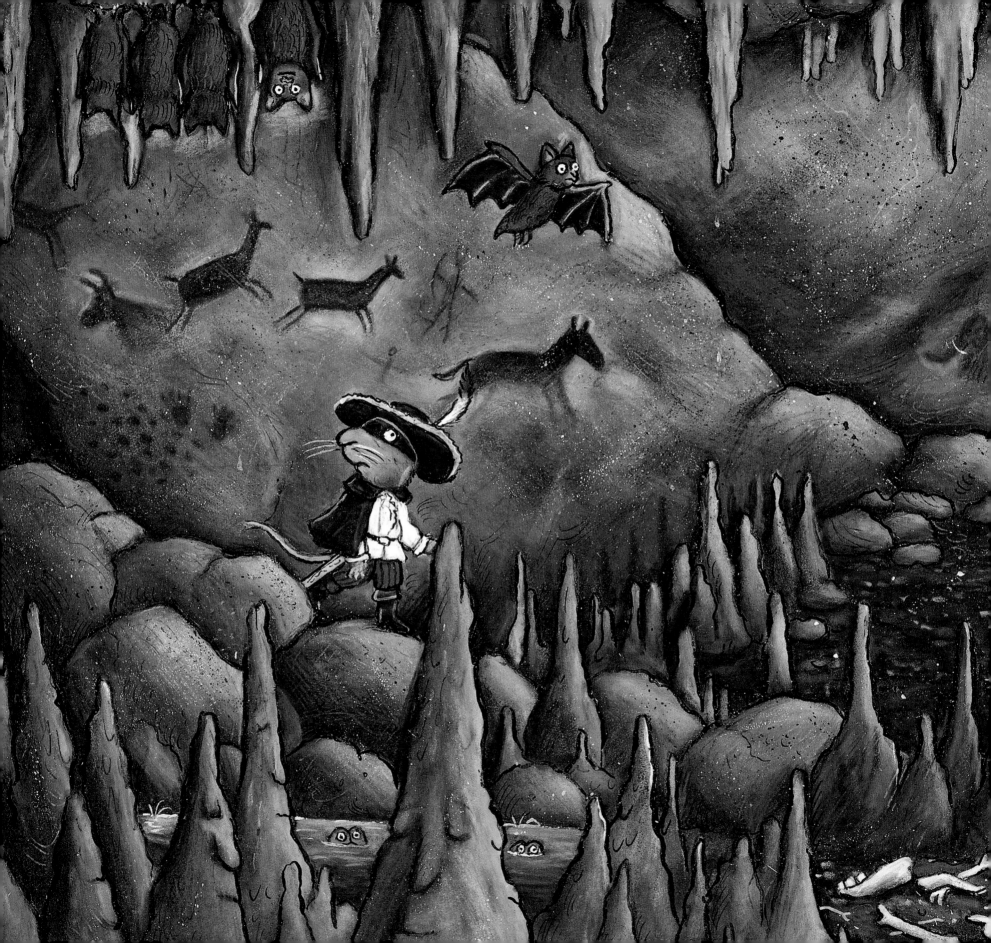

And as for the Rat in the echoey cave,
he shouted and wandered, till . . .

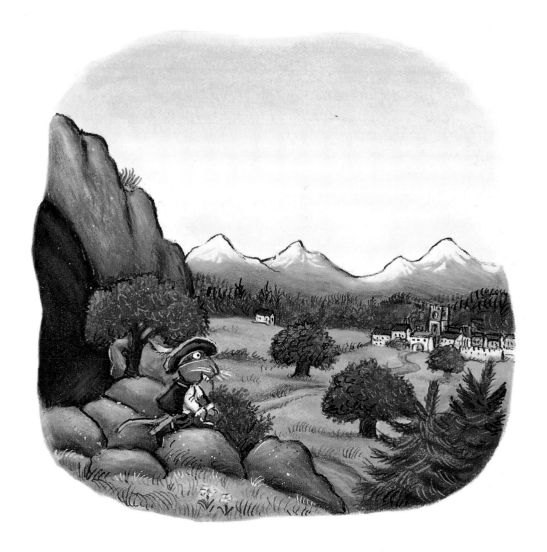

He found his way out of the darkness,
on the other side of the hill.

A thinner and greyer and meeker Rat,
 he robs on the road no more,
For he landed a job in a cake shop –
 A cake shop – a cake shop –
And they say he still works in the cake shop,
 sweeping the cake shop floor.

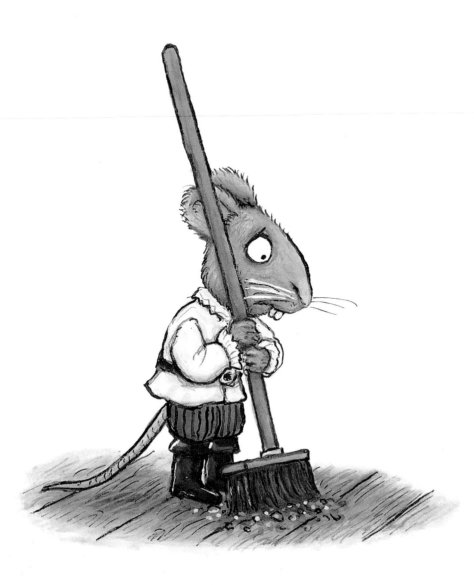

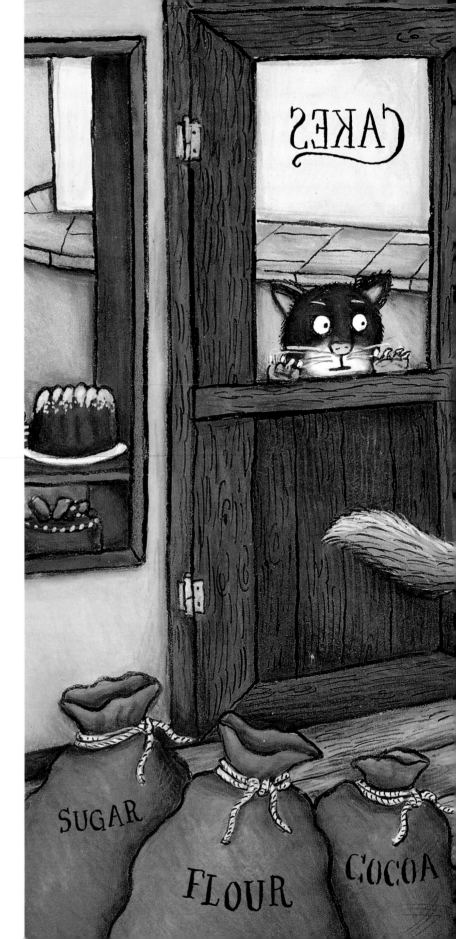

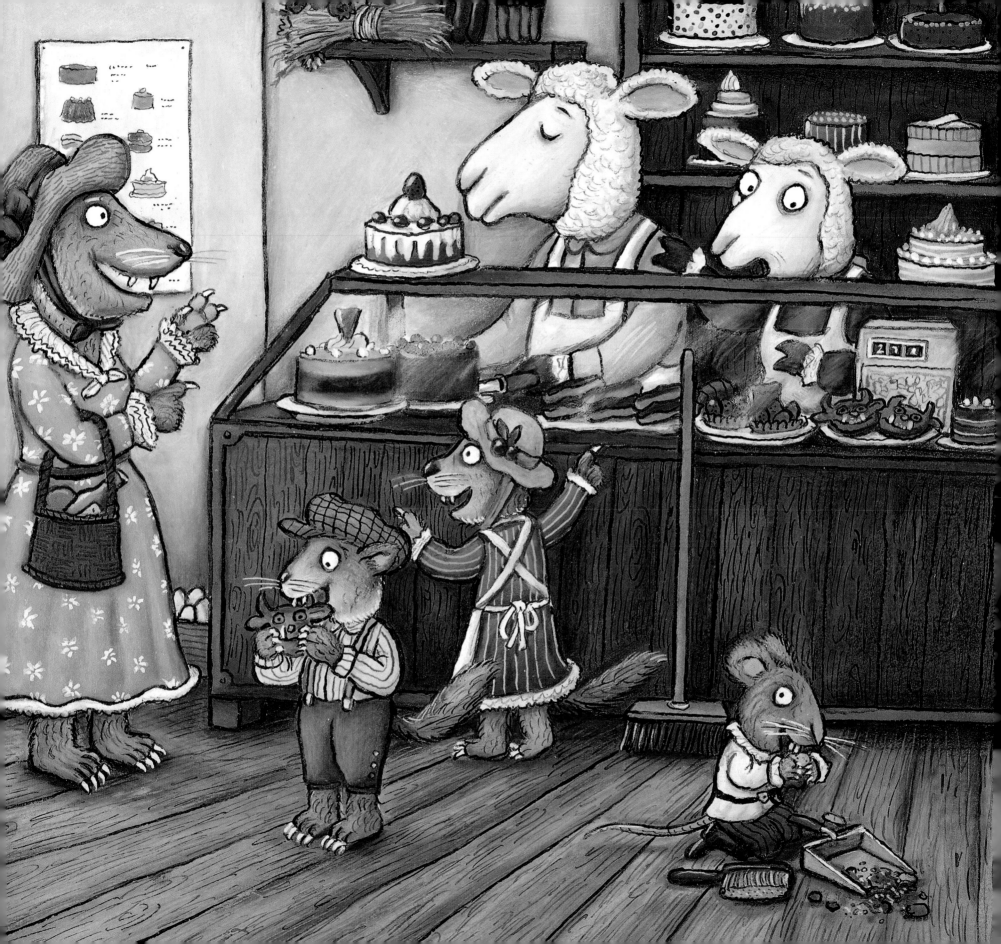

For Dominic – J.D.

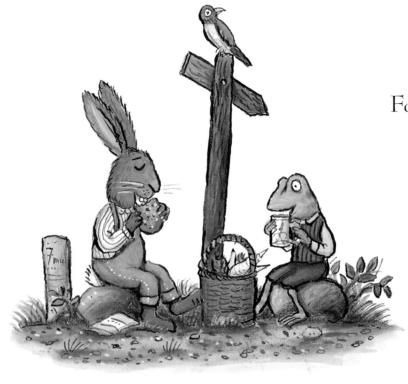

For Adélie – A.S.

First published in the UK in 2011 by
Alison Green Books
An imprint of Scholastic Children's Books
Euston House, 24 Eversholt Street
London NW1 1DB, UK
A division of Scholastic Ltd
www.scholastic.co.uk
London – New York – Toronto – Sydney – Auckland
Mexico City – New Delhi – Hong Kong

Text copyright © 2011 Julia Donaldson
Illustrations copyright © 2011 Axel Scheffler

HB ISBN: 978 1 4071 24 37 7

All rights reserved.
Printed in Singapore

1 3 5 7 9 10 8 6 4 2

The moral rights of Julia Donaldson and Axel Scheffler have been asserted.

Papers used by Scholastic Children's Books are made from wood grown in sustainable forests.

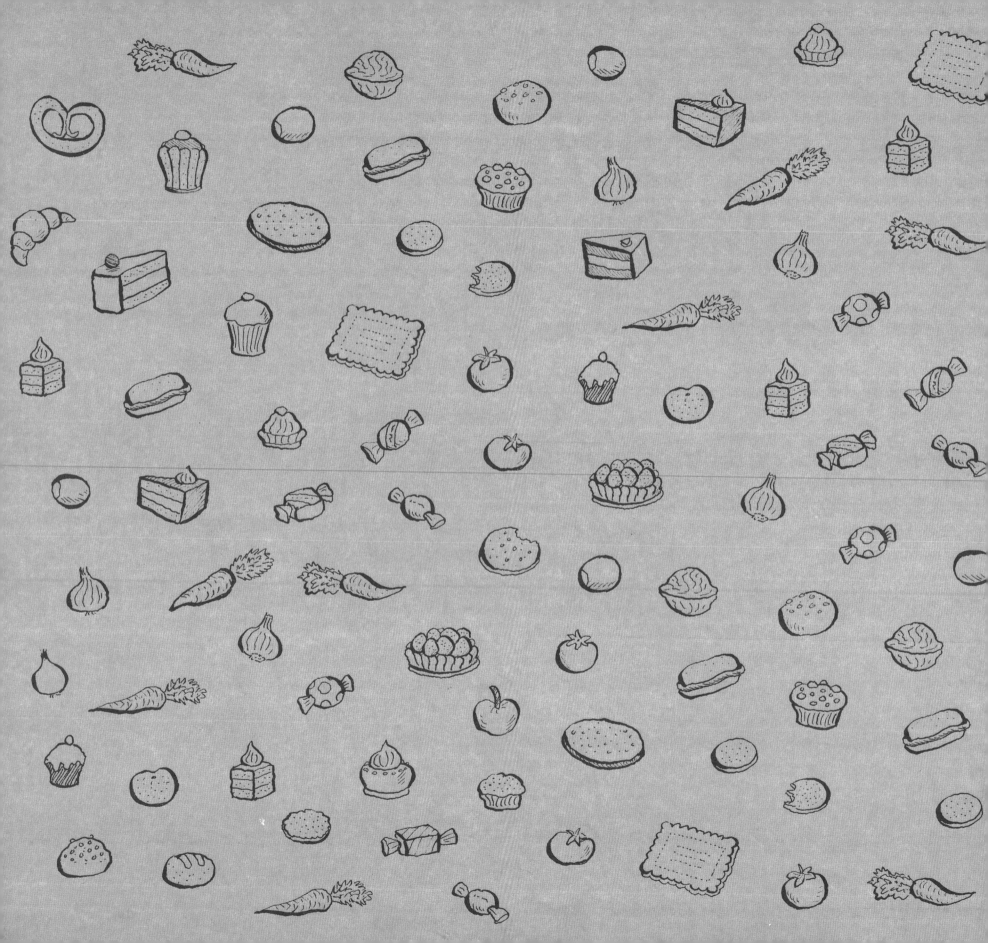